Copyright ©2014
All rights reserved
Published in Los Angeles
Arts District Publications

ISBN-13 9781492234227
ISBN-10 1492234222

When Good Toys Go Bad

*Toys take the dioramic stage and tell stories,
not always coming from a happy place.*

FORWARD

Toys are designed to exist in a limited realm. Every toy character portrays a particular perspective that the children who play with it can easily re-enact. Whether it's Cinderella – whose longing for a better life is magically fulfilled by Prince Charming – or G.I. Joe, ready to spring into military battle at any given moment, these figures make absolute sense in their restricted domains.

But what if they were somehow liberated from their simplistically intended realms? Would they be able to adjust to the complexities of the world as we know it? Barbie tried. The best she could do, though, was to split herself off into disharmonious multiple personalities. Her true fashion model essence was morphed into variations as unlikely as paratrooper, yoga instructor, UNICEF diplomat, computer engineer, and NASCAR driver.

Unlike Barbie, the toy characters in *When Good Toys Go Bad* remain true to themselves after escaping from their original realms. In *Angry At Saturn*, incensed rural inhabitants turn their fury toward science. In *The Other Kind*, a pair of wide-eyed innocent children gets a sudden dose of adult entertainment. In *Encounter*, innocuous farm animals take on a bold malevolence as they outnumber an unsuspecting, freewheeling rabbit. How do our transported friends fare in their new surroundings? You decide.

- Richard Pfefferman
Author of *Strategic Reinvention in Popular Culture*: *The Encore Impulse*

When Good Toys Go Bad :: Image Sequence

Angry At Saturn

Terror Threat

Stay

Film Critics

The Other Kind

Two For the Road

Angry At Rubik

Disco Inferno

Looking For Love

Hod Up

Encounter

Discovery

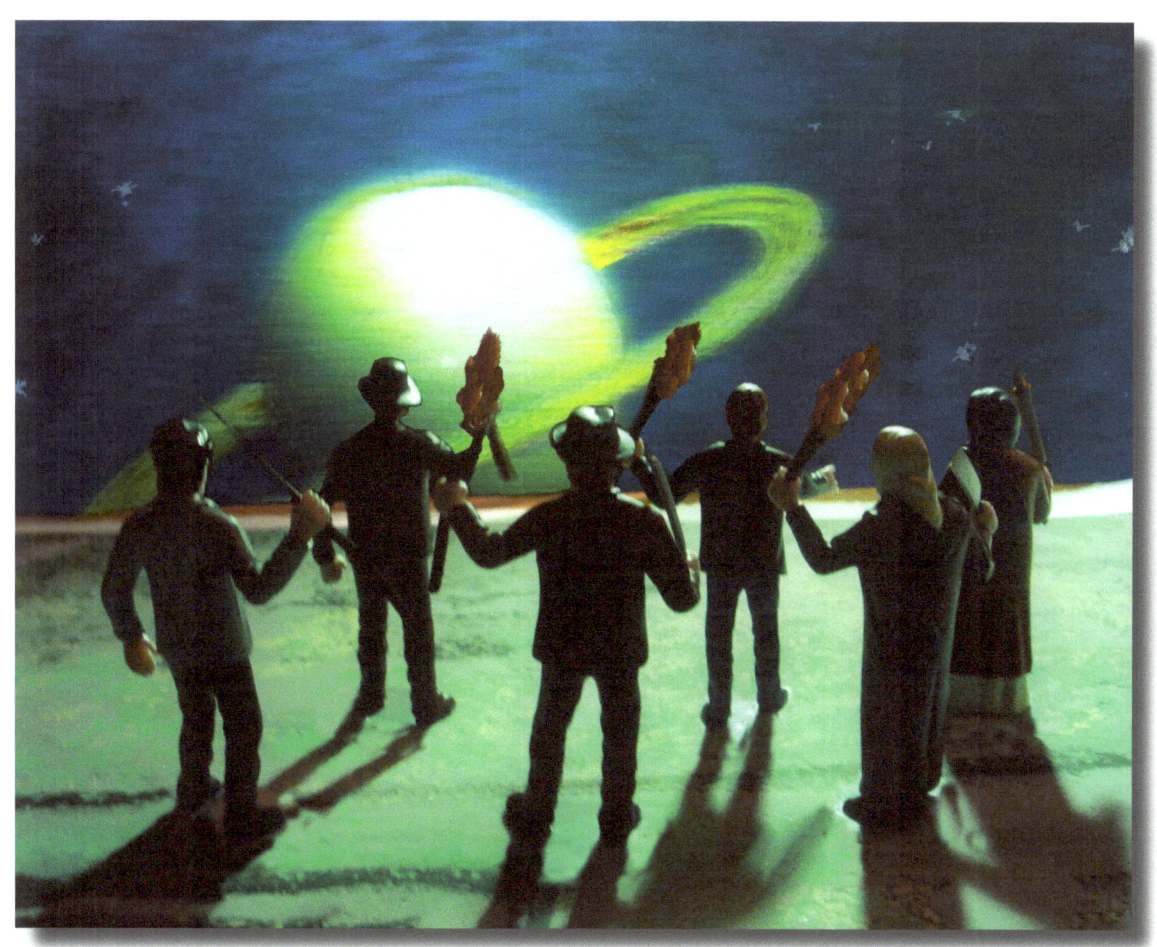

Angry At Saturn

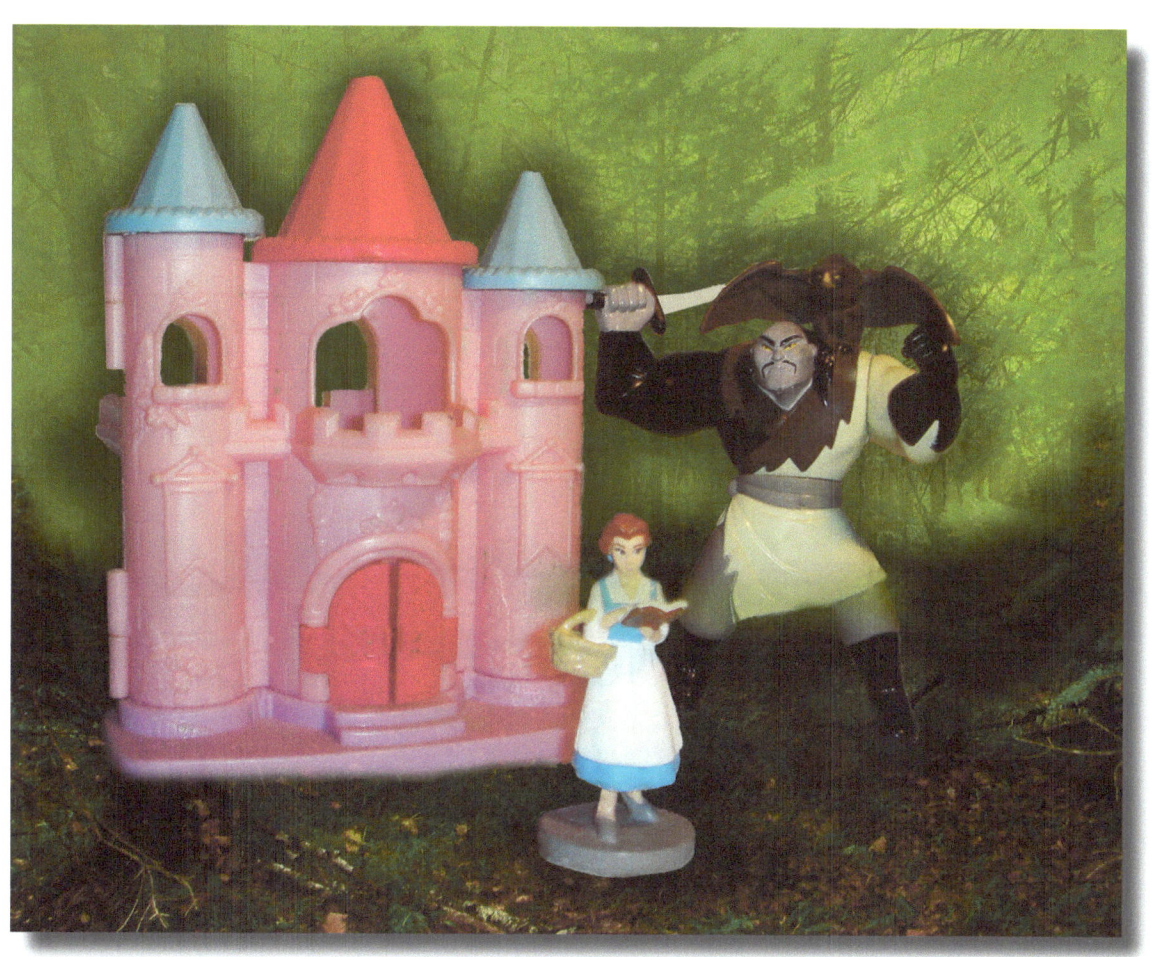

Terror Threat

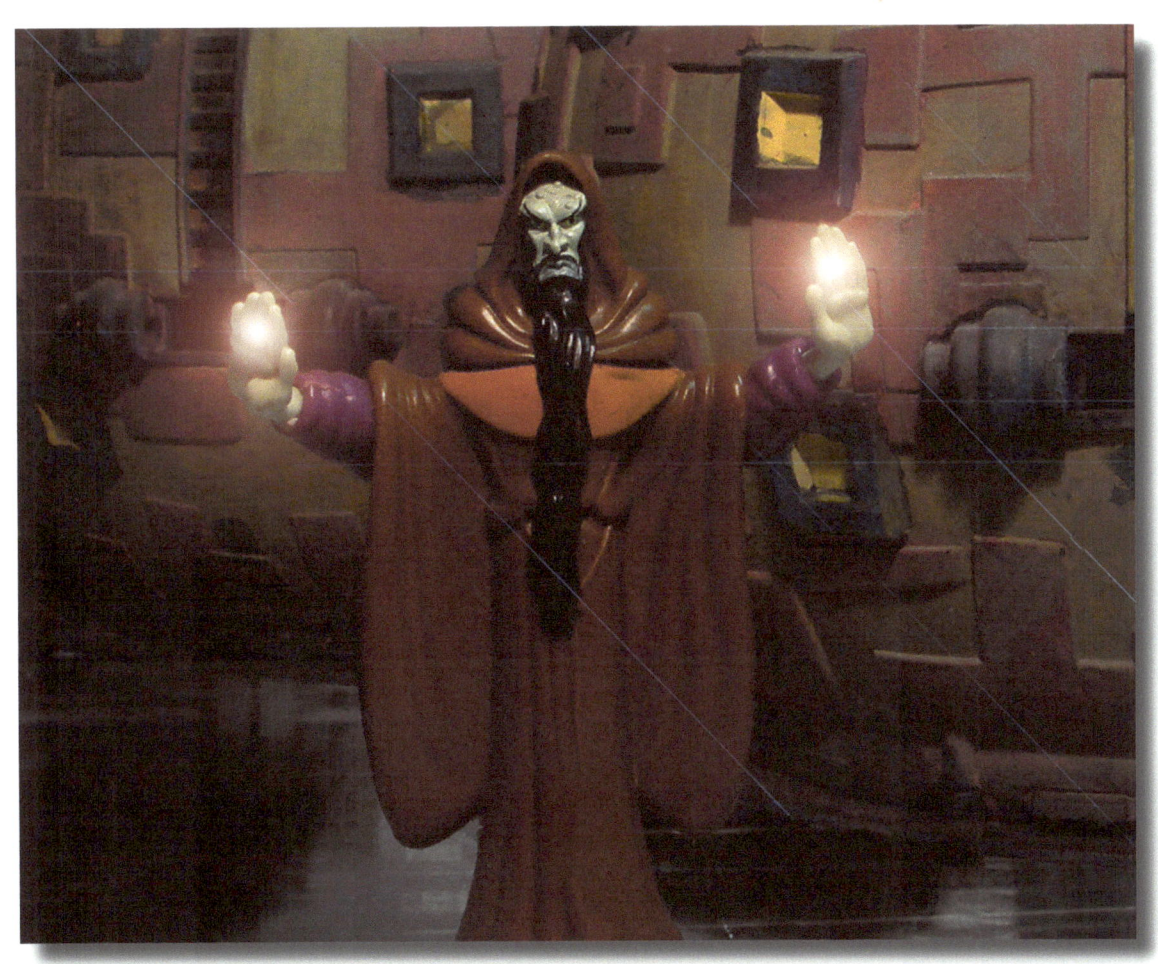
Stay

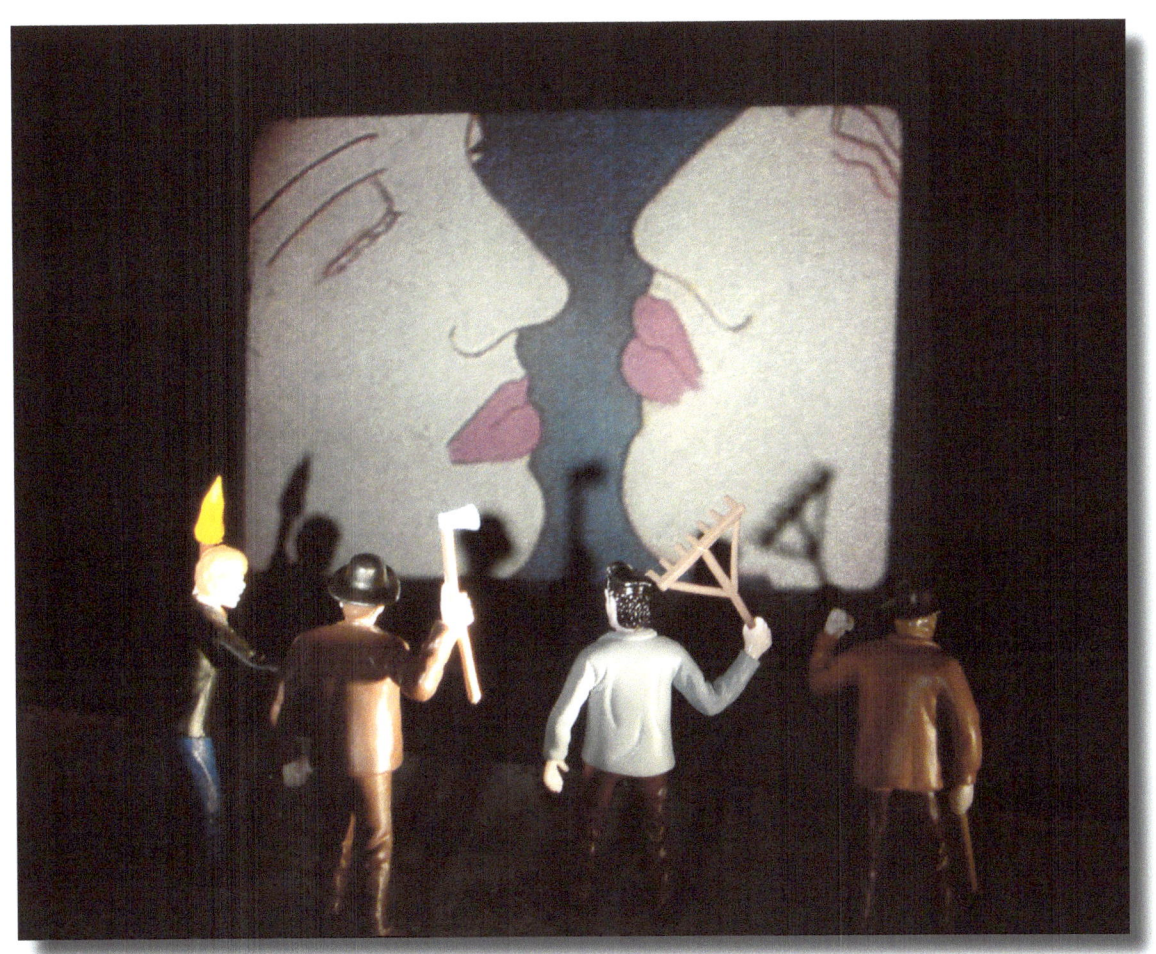
Film Critics

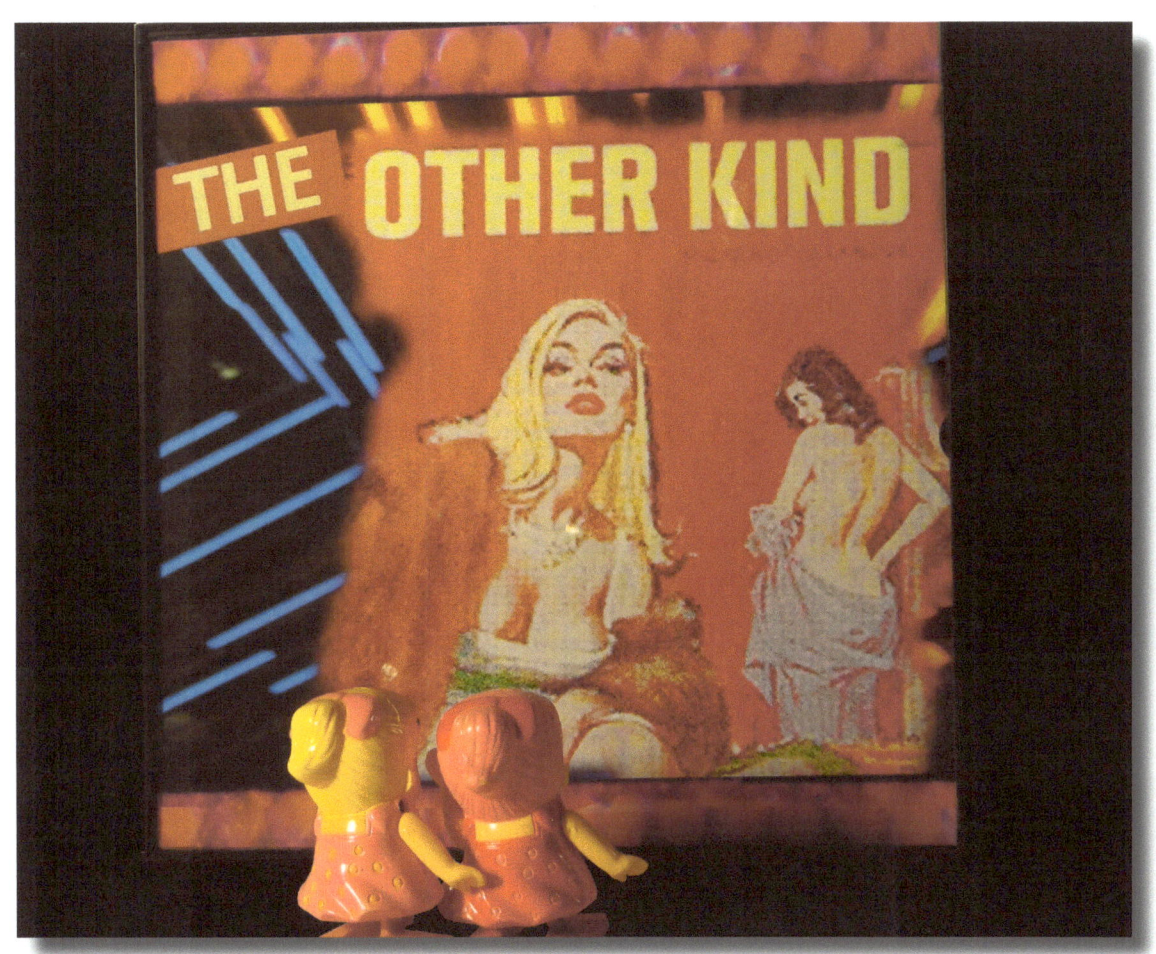

The Other Kind

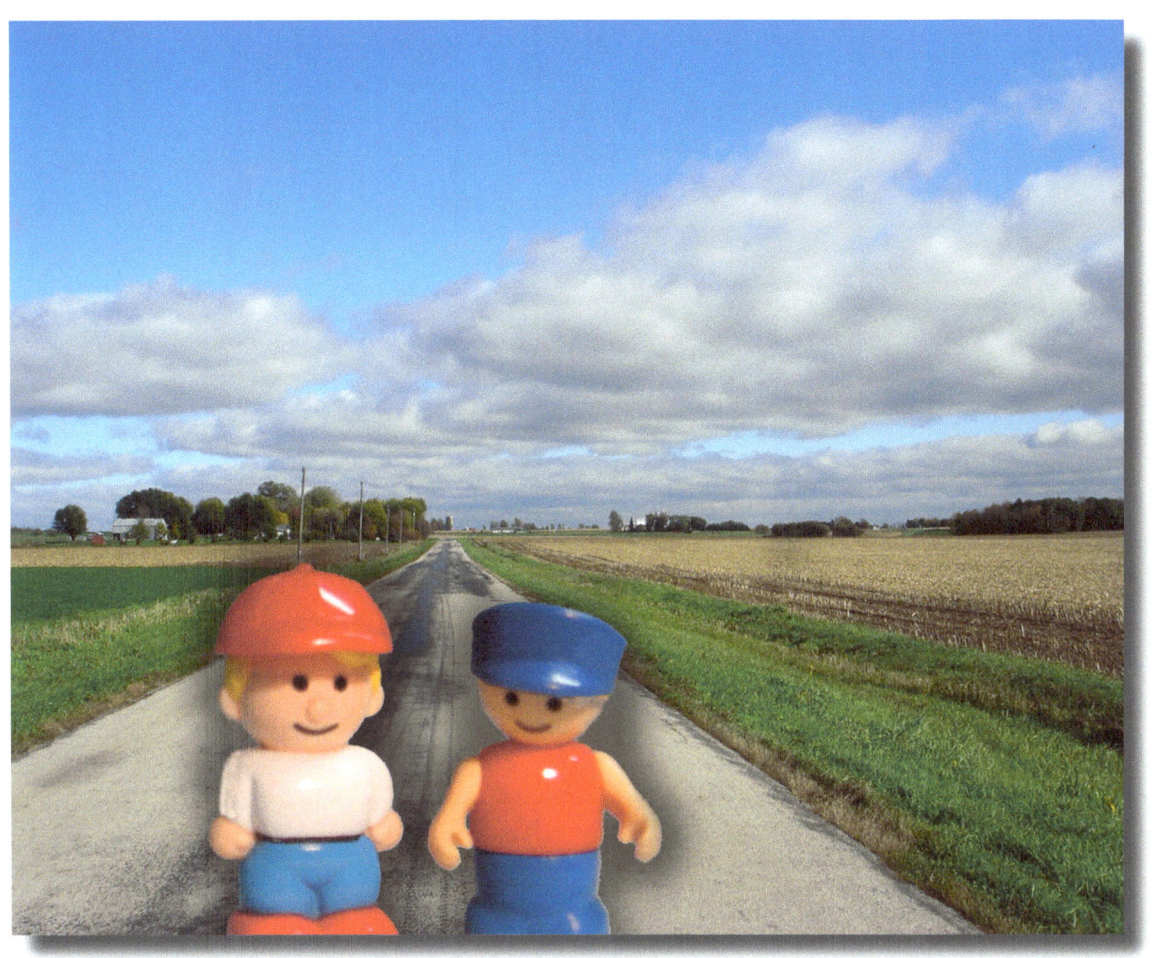

Two For The Road

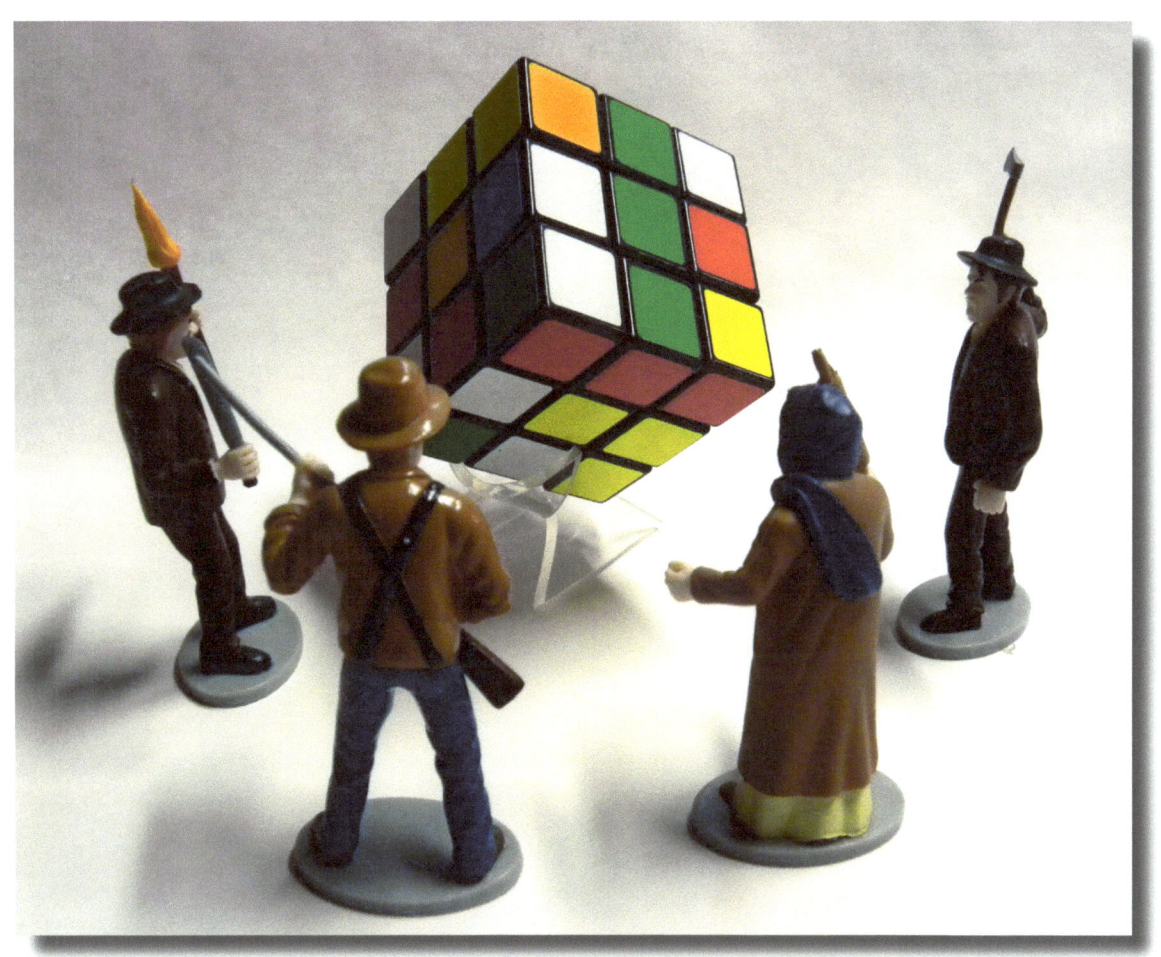

Angry At Rubik

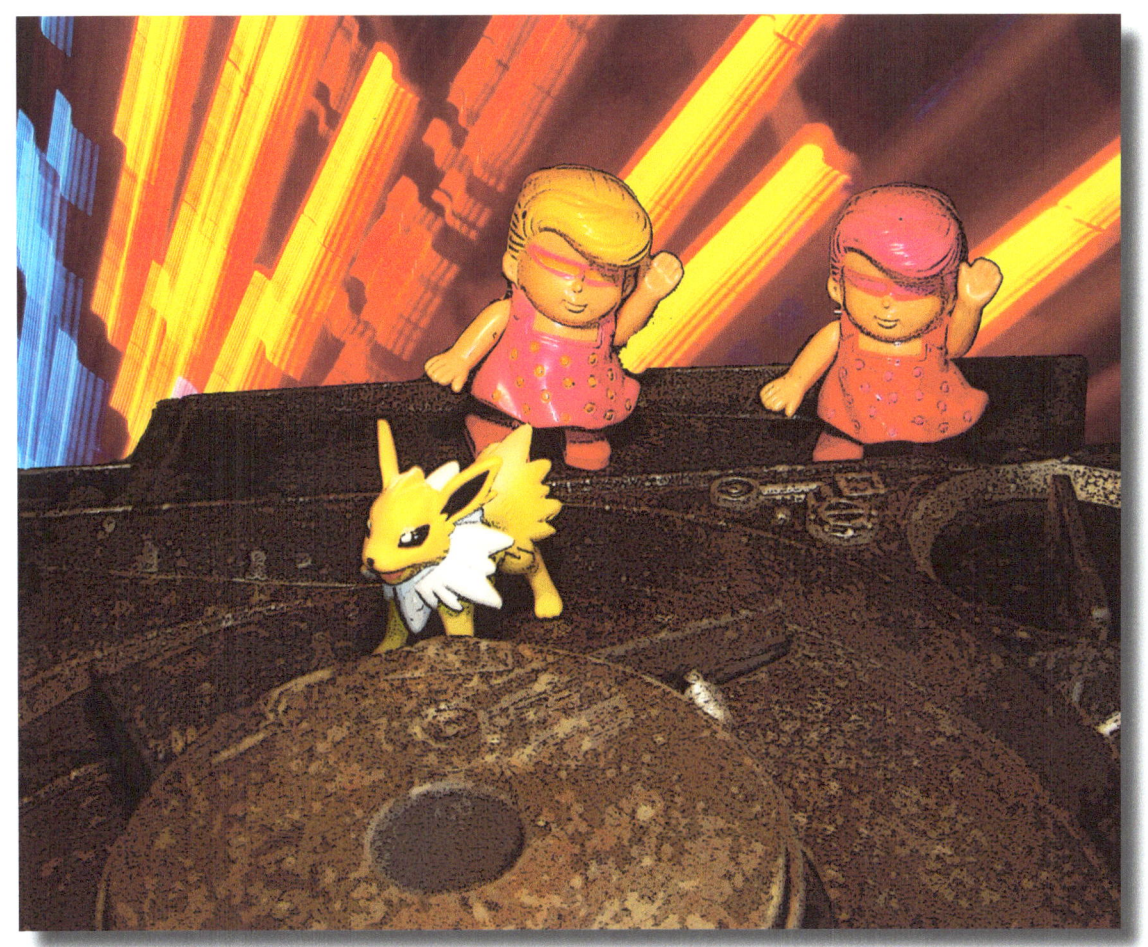

Disco Inferno

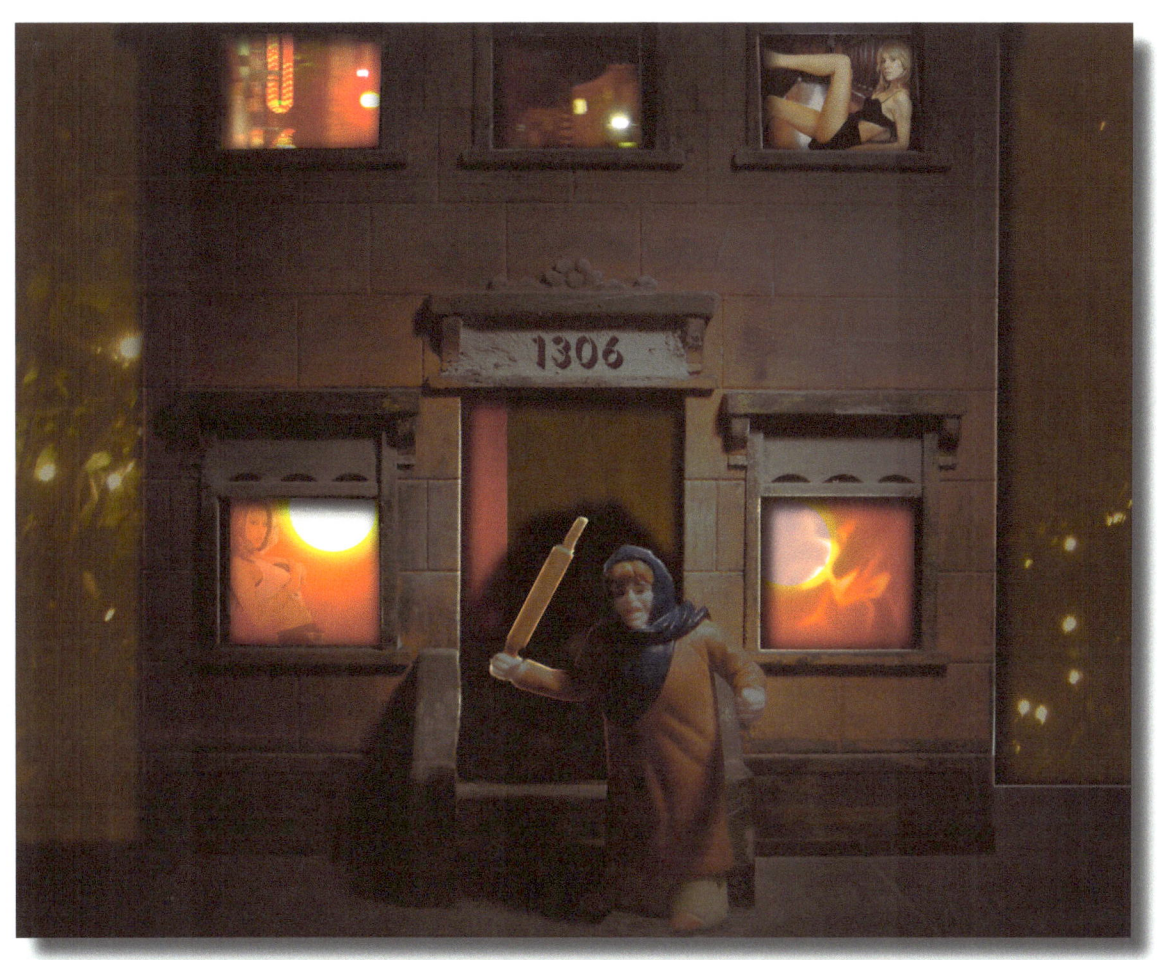

Looking For Love In All The Wrong Places

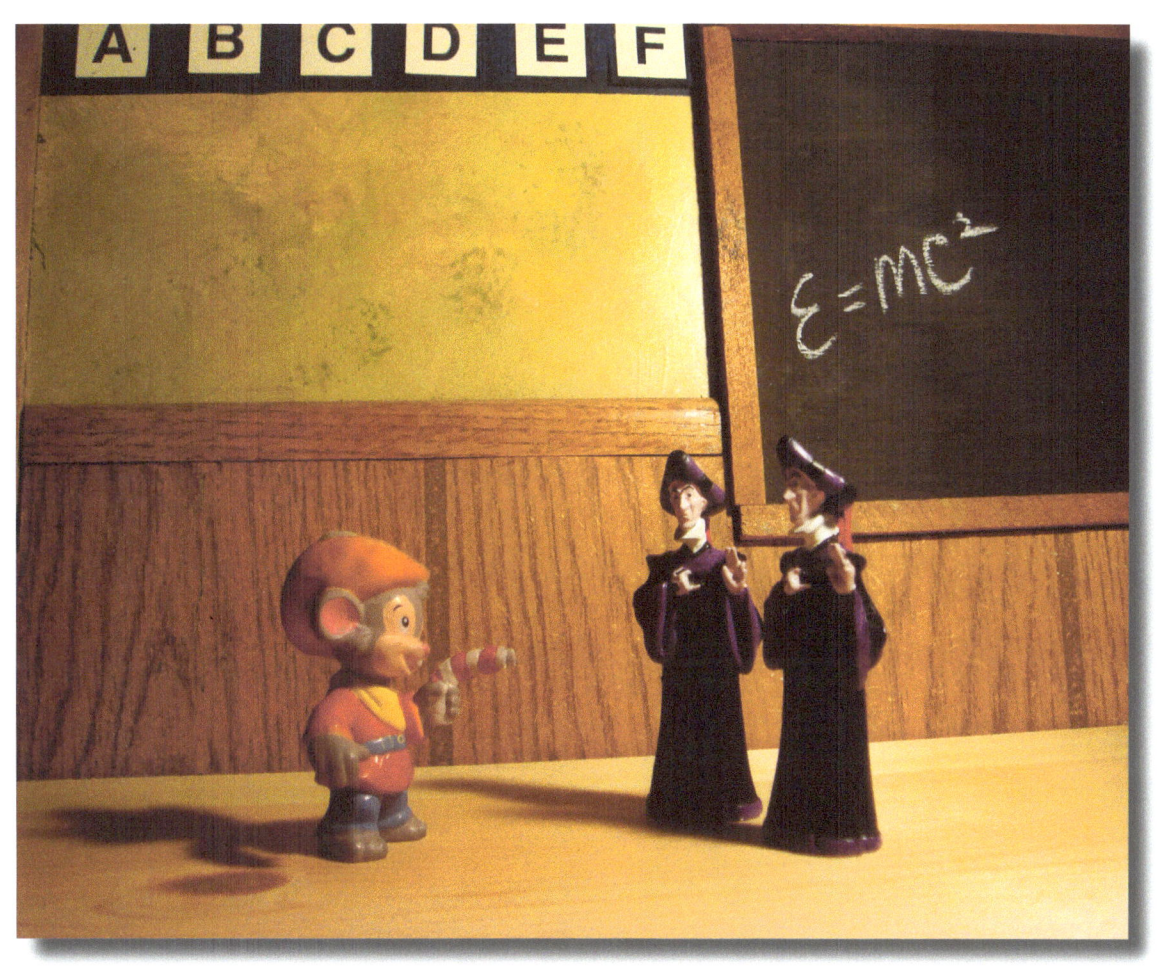

Hod Up

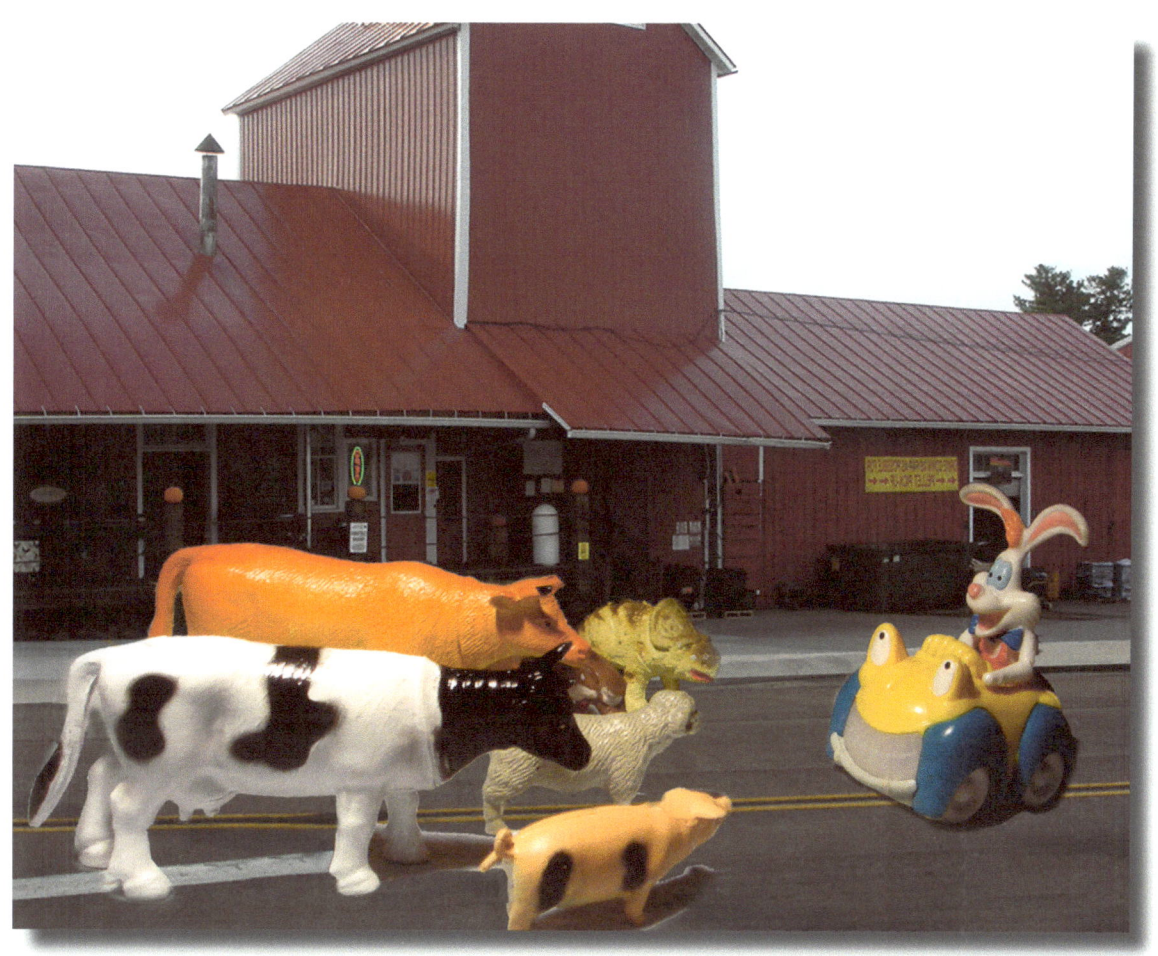

Encounter

Discovery

Art Review: "When Good Toys Go Bad" by Anna Broome

Qathryn Brehm's latest photographs offer a humorous and hard eye discussion of social convention, sexual identity and intellectual evolution.

The images juxtapose esoteric with accessible ideas and settings to welcome the audience to the piece while still allowing them to ask and answer their own questions.

Utilizing props against photography in eye candy motifs heralding mob mentality, sexual cacophony and absolute love, Brehm pulls images from an infinite catalog collected over the years. In "The Other Kind" the innocence of child love is contrasted with the complexity of adult love, i.e. sex, societies view of sexuality and the big screen's depiction of same sex love.

Brehm states, "I am articulating images from a verbal place and see the words and extend them, through the entire story, through image."

Angry at Saturn, Angry at Rubik and *Film Critics* explore transfixed mentality against science, art, exploration and progress. With a humorous poke at the futility of anger as a group, or individual for that matter, with a response to situations that are large and complex, or simply unalterable parts of existence. The use of rural figurines as an image of prejudice offer a cascading humor as nitty-gritty battle between them and their abstract counterparts result in neither victory nor defeat.

Looking for Love in All the Wrong Places shows a housewife in the foreground of a brothel waiting for her husband who is out of frame. The image of a wife contrasted with prostitute offer almost sympathy for the husband expected at home, yet the title contradicts image to form irony as the question becomes how do we define love, sex and the equal importance of home and family.

In *Hod Up,* an armed mouse finds himself trying to rob knowledge and education, which can't be stolen and are of greater value than anything. Positioning himself between the alphabet and The Theory of Relativity the full compass of mind's exploration is on the line in a battle between mouse and man.

Brehm's centrifugal staged photo dioramas communicate complicated themes and discussion: however, an elegance non-the-less pivots around the hard imagery; an elegance of romance, journey, enlightenment perhaps detailing optimism, a courageous affable center in Brehm's world view. Brehm speaks of her work, "My desire to create means I never have to stop listening, engaging, observing or dreaming."

Anna Broome is a Downtown Los Angeles poet, painter and member of poetry/spoken word troupe Story Phile. She teaches poetry at Art Share LA. Her new collection of poems, 'Pineapples' .

About The Artist

Qathryn Brehm uses textures and color and a huge love of toys to shape whimiscal and sometimes pointed creations. Her juxtapositions of pop culture images and classic iconic visuals render the usual unusual, and make us wonder why we hadn't noticed that before.

In 1980 she worked as consultant, and developed conceptual imagery for Ogilvy and Mather, Warner Bros., E! Entertainment, Teleflora, Yamaha, Genesco, Disneyland Hotel, Shaw-Walker, The Disney Channel and Mattel Toys.

Outstanding series include "The Girl Groups" on music from the 1960s, "Saints and Sinners," and "Toy Box," Her work is often constructed from found objects, mixed media and photo-generated images.

Qathryn Brehm's studio is in Los Angeles,
a town loaded with color, texture and many toys.

info@qathryn.com
www.qathryn.com
Los Angeles CA 90013
United States

Twitter
FaceBook
Instagram
Pintrest

Many thanks to MP, Tara Devine, Sally Wolf,
Harrison & Max & KT McArthy

From Arts District Publications
Urban Saint Cards
Arts District Postcards
www.artsdistrictpublications

www.ingramcontent.com/pod-product-compliance
Lightning Source LLC
Chambersburg PA
CBHW050841180526
45159CB00004B/1982